Serenity Landscapes: A Relaxing Coloring Book

PEACE LAND COLORING

Copyright © 2023 Peace Land
All rights reserved.

ISBN: 979-8-9863719-2-4

For the Coloring Enthusiast:

Who says coloring is just for kids? It's a way for us teens or adults to unleash our inner child, to create something beautiful, and to take a break from the chaos of the world. So, grab your colored pencils or crayons, find a cozy spot, and let the coloring magic begin. Just remember, stay inside the lines, or don't, because who are we to judge? Happy coloring :-)

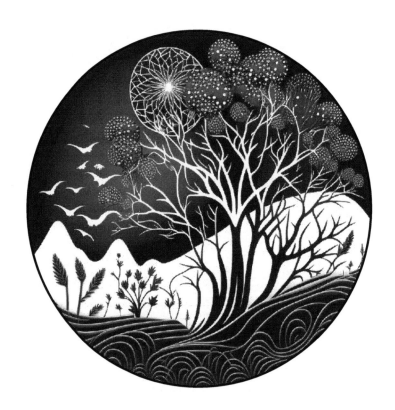

All rights reserved. No part of this publication may be reproduced, stored in a retrieval system, or transmitted, in any form or by any means, electronic, mechanical, photocopying, recording, or otherwise, without the prior written permission of the publisher. Any unauthorized copying, sharing, or distribution of the contents of this coloring book is strictly prohibited and may result in civil and criminal liability. The publisher and author do not accept any liability whatsoever for any loss or damage caused by your use of this coloring book. By purchasing this coloring book, you agree to abide by all applicable copyright laws and regulations.

THANK YOU

WE ARE SO EXCITED THAT YOU'VE CHOSEN OUR COLORING BOOK

Welcome to the world of coloring, a place where imagination and relaxation meet. This coloring book is not just a book, it's a labor of love dedicated to our beloved grandparents who are no longer with us. They instilled in us a love for art and creativity, and we wanted to share that love with you and the world.

Whether you're a seasoned colorist or just starting out, we hope this book becomes your new favorite way to unwind, destress, and escape into a world of color.

To make the most of your coloring experience, we recommend using colored pencils or crayons. If you prefer to use markers or paint, just be sure to place a blank sheet of paper behind your artwork to prevent any bleed-through.

So, take a deep breath, relax, and let your creativity flow as you are about to unleash your creativity with 45 one-of-a-kind coloring pages. Thank you again for being a part of this journey and for allowing us to share our passion with you. Let's get coloring :-) !

If you enjoyed coloring in this book and want to spread the word, we would love for you to leave a review on Amazon. Your honest opinion will help other coloring enthusiasts discover our book and inspire us to create even more amazing content in the future.

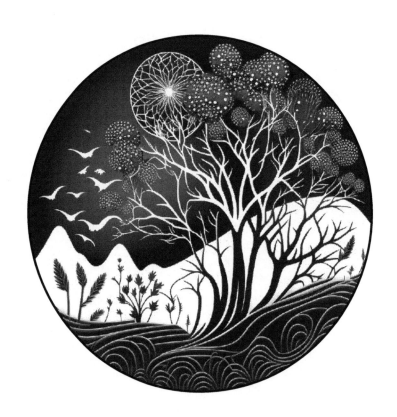

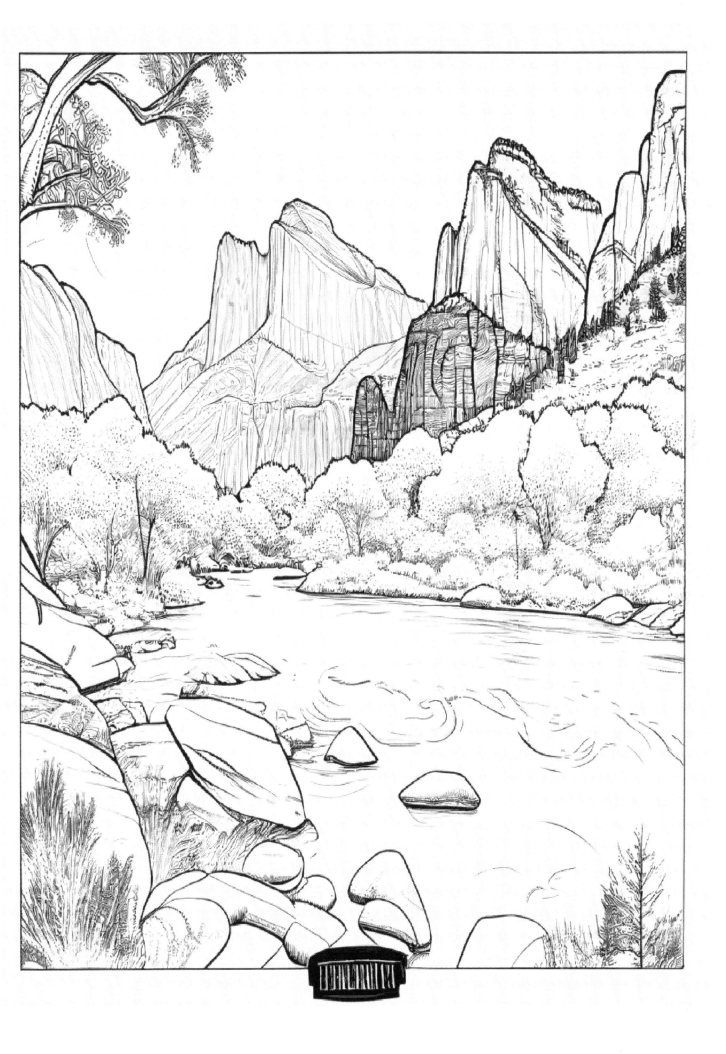

Serenity Landscapes: A Relaxing Coloring Book

Serenity Landscapes: A Relaxing Coloring Book

Serenity Landscapes: A Relaxing Coloring Book

Serenity Landscapes: A Relaxing Coloring Book

Serenity Landscapes: A Relaxing Coloring Book

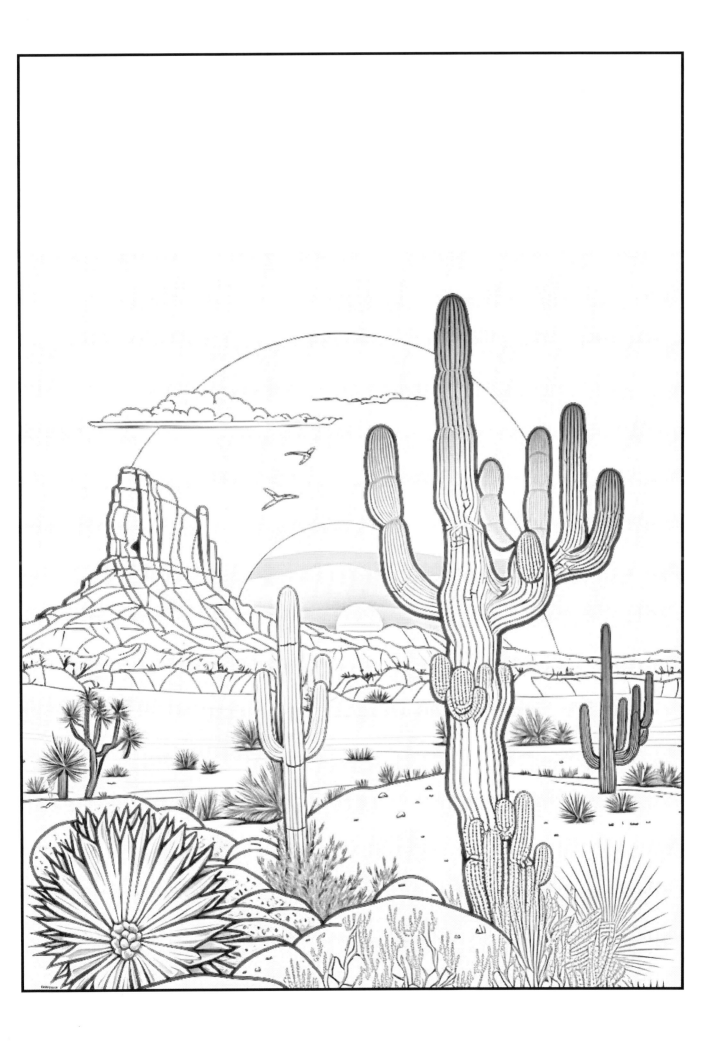

Serenity Landscapes: A Relaxing Coloring Book

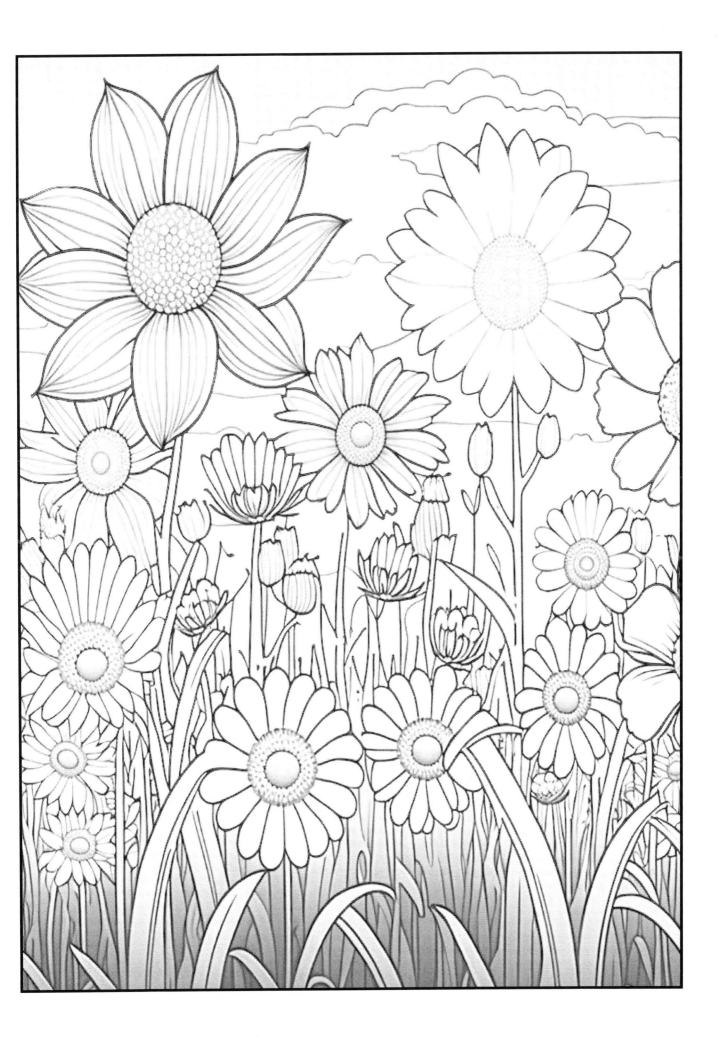

Serenity Landscapes: A Relaxing Coloring Book

Serenity Landscapes: A Relaxing Coloring Book

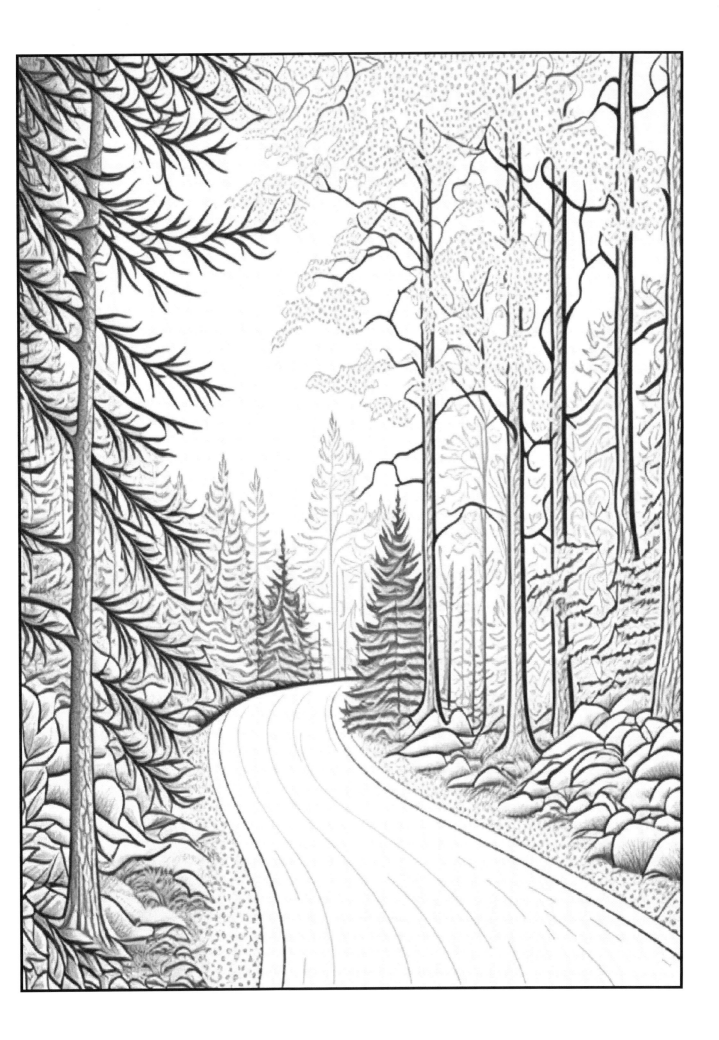

Serenity Landscapes: A Relaxing Coloring Book

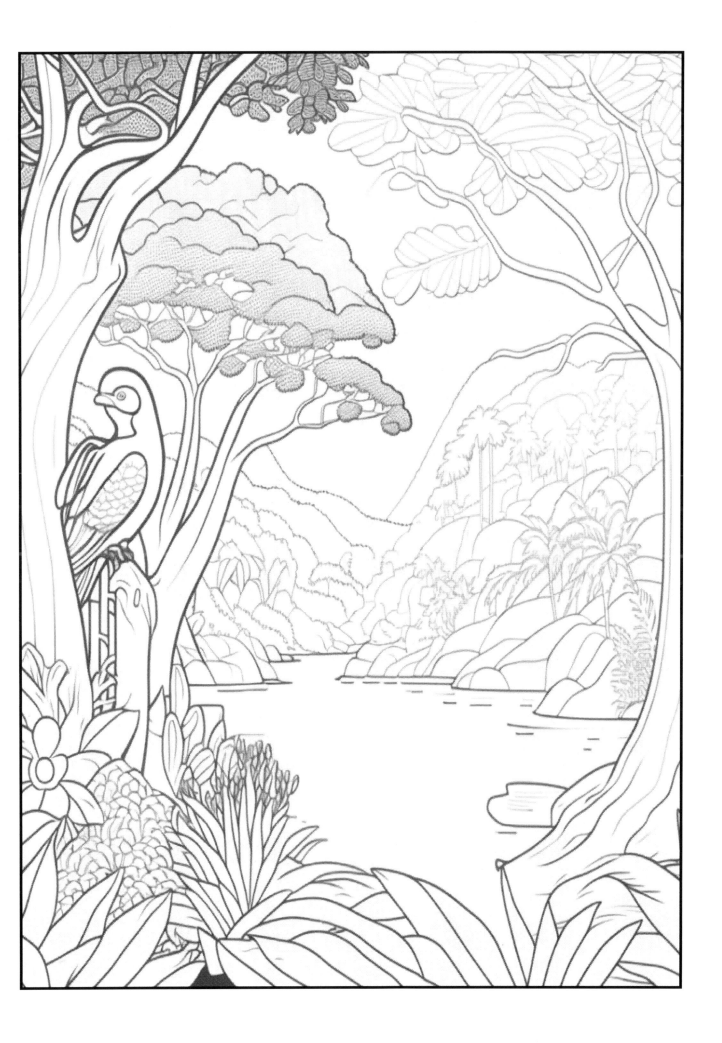

Serenity Landscapes: A Relaxing Coloring Book

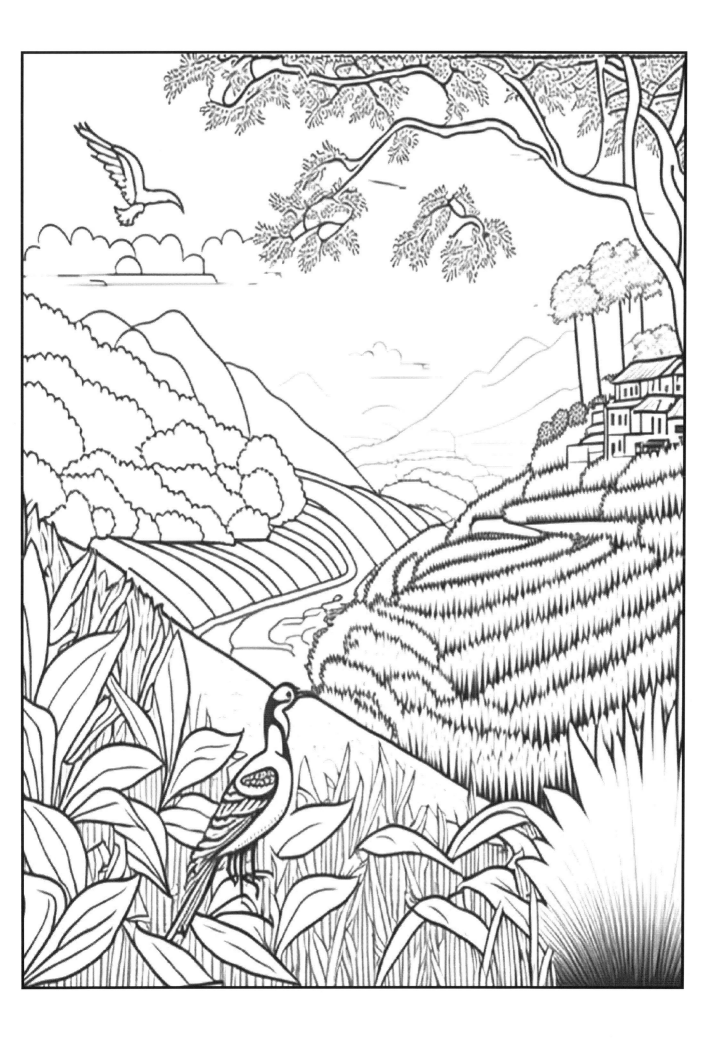

Serenity Landscapes: A Relaxing Coloring Book

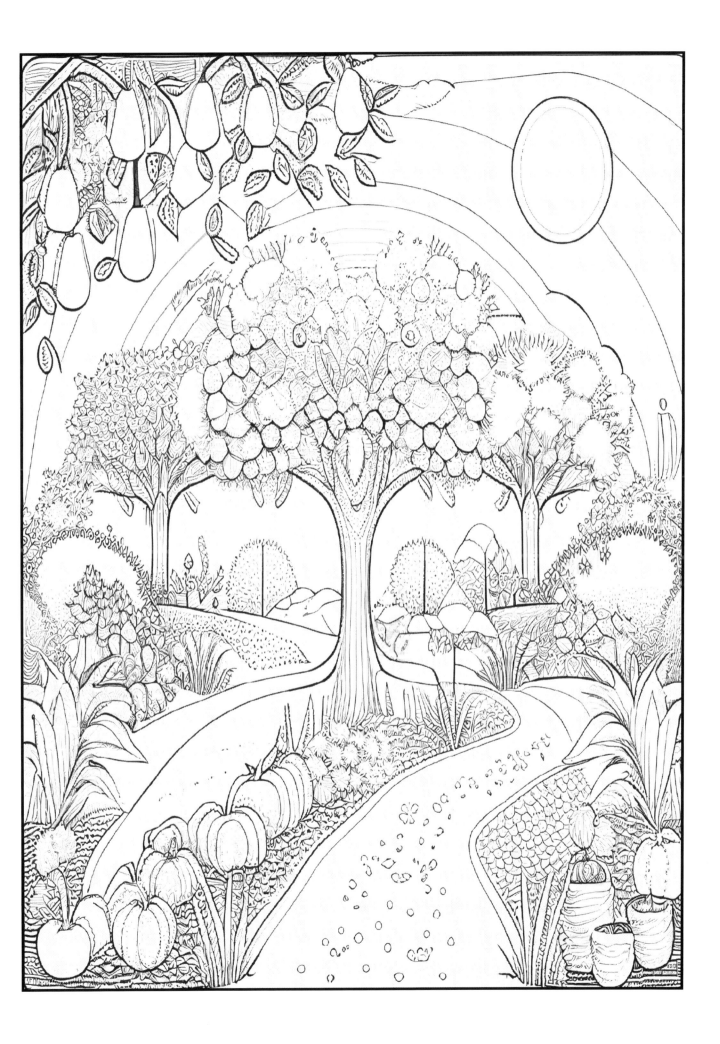

Serenity Landscapes: A Relaxing Coloring Book

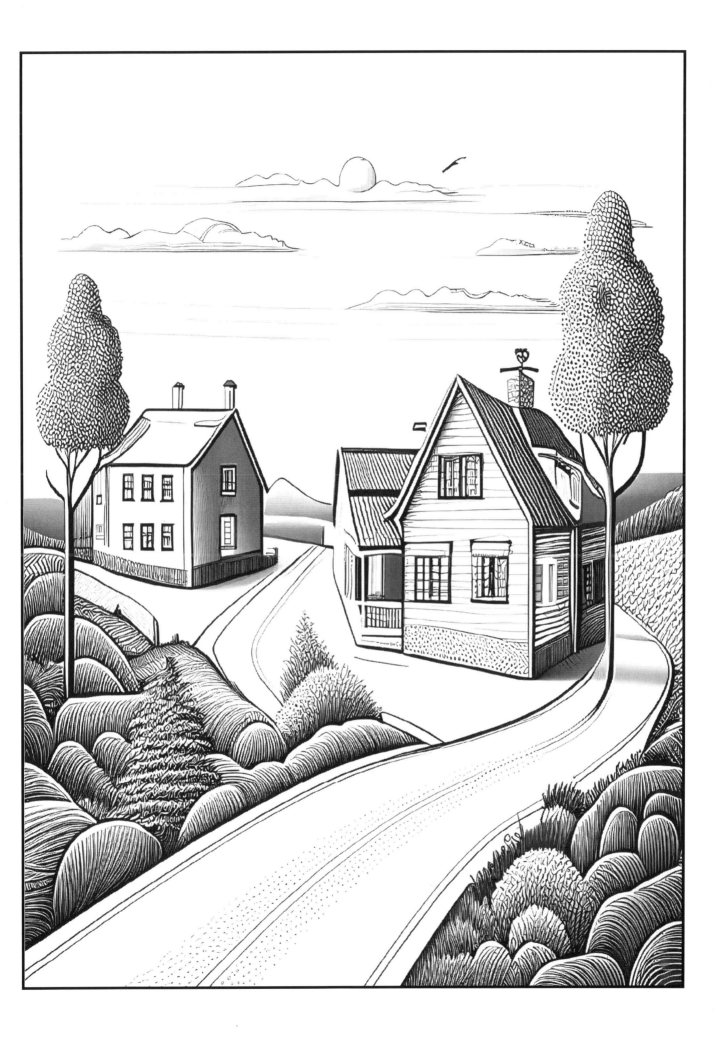

Serenity Landscapes: A Relaxing Coloring Book

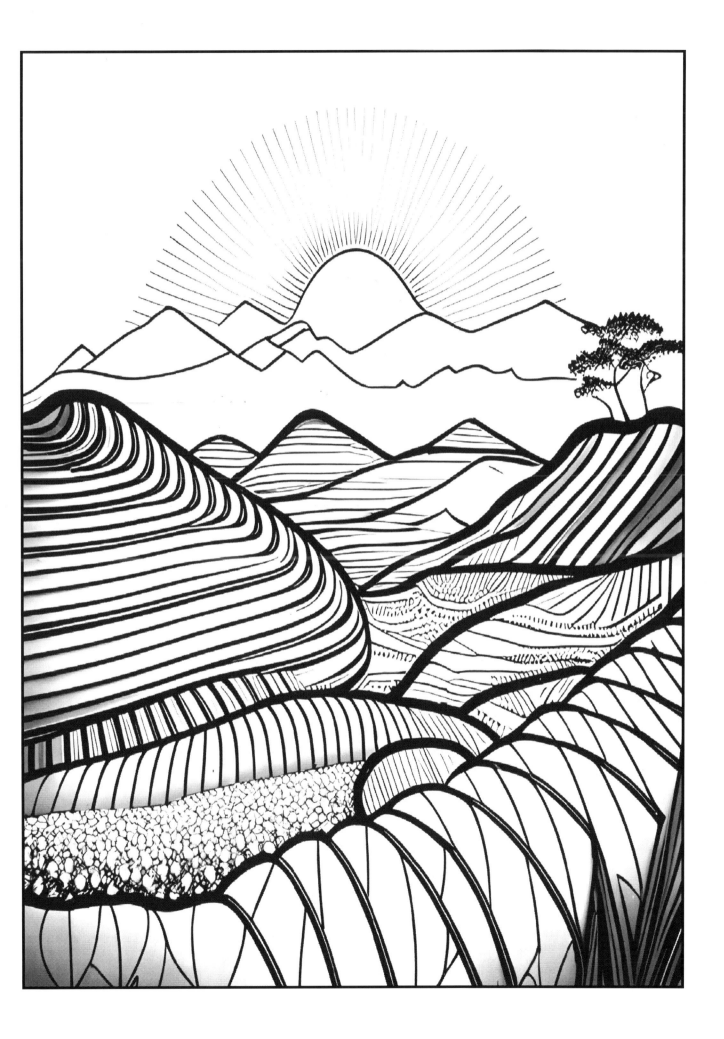

Serenity Landscapes: A Relaxing Coloring Book

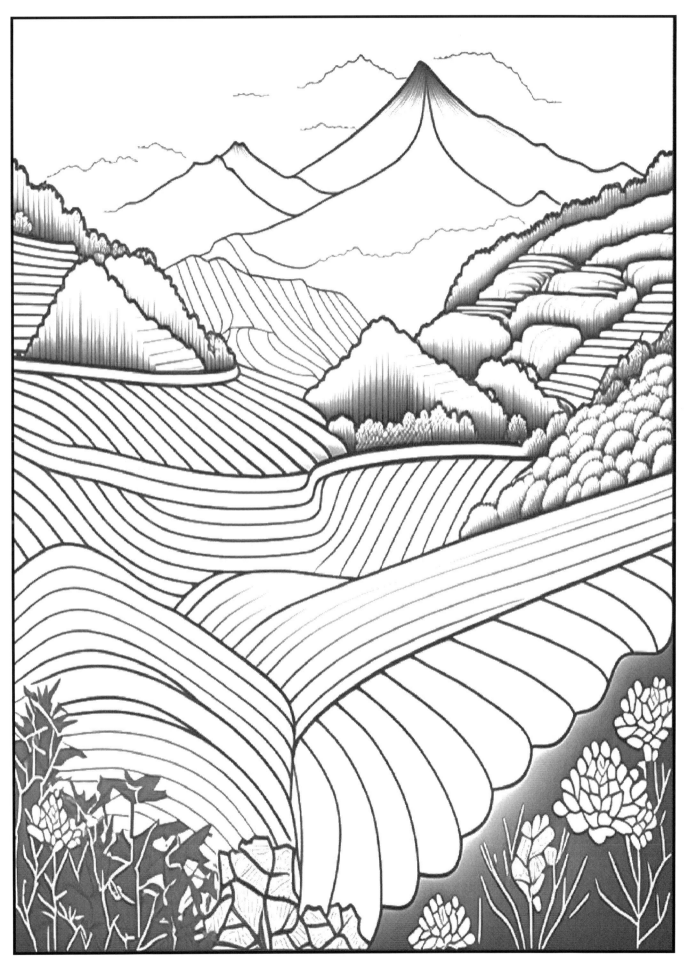

Serenity Landscapes: A Relaxing Coloring Book

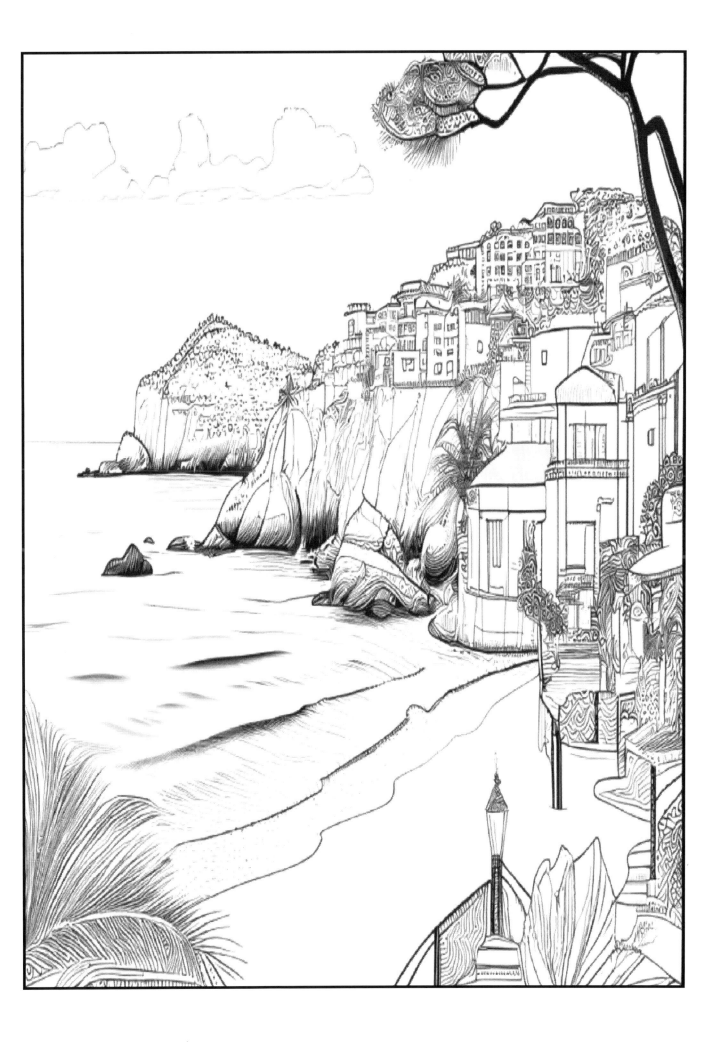

Serenity Landscapes: A Relaxing Coloring Book

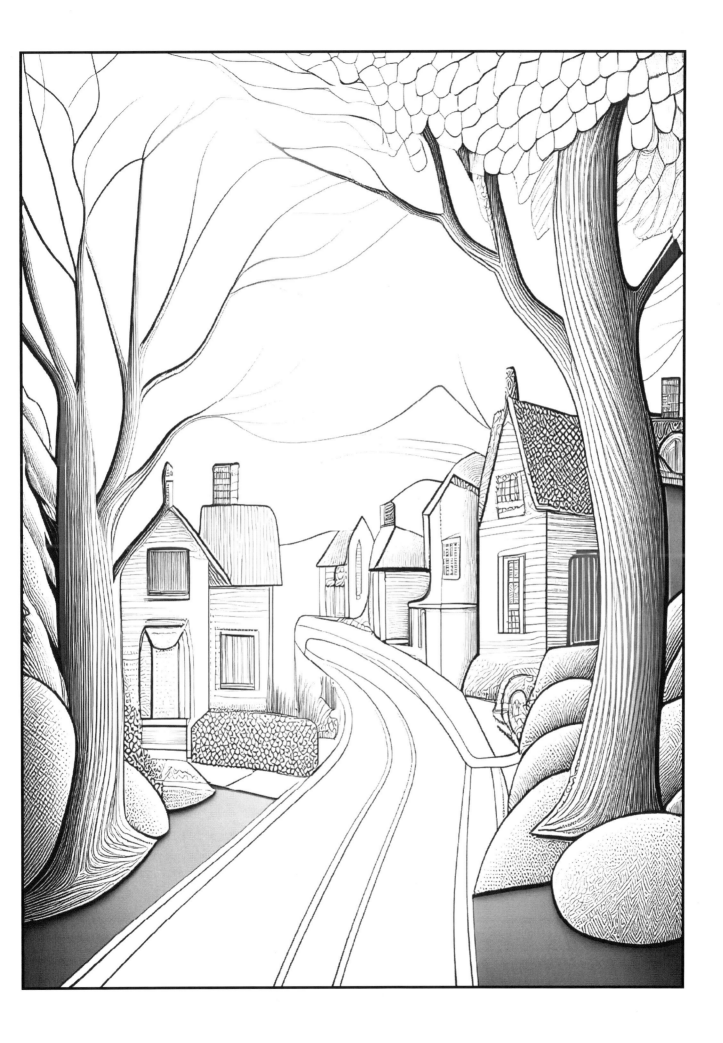

Serenity Landscapes: A Relaxing Coloring Book

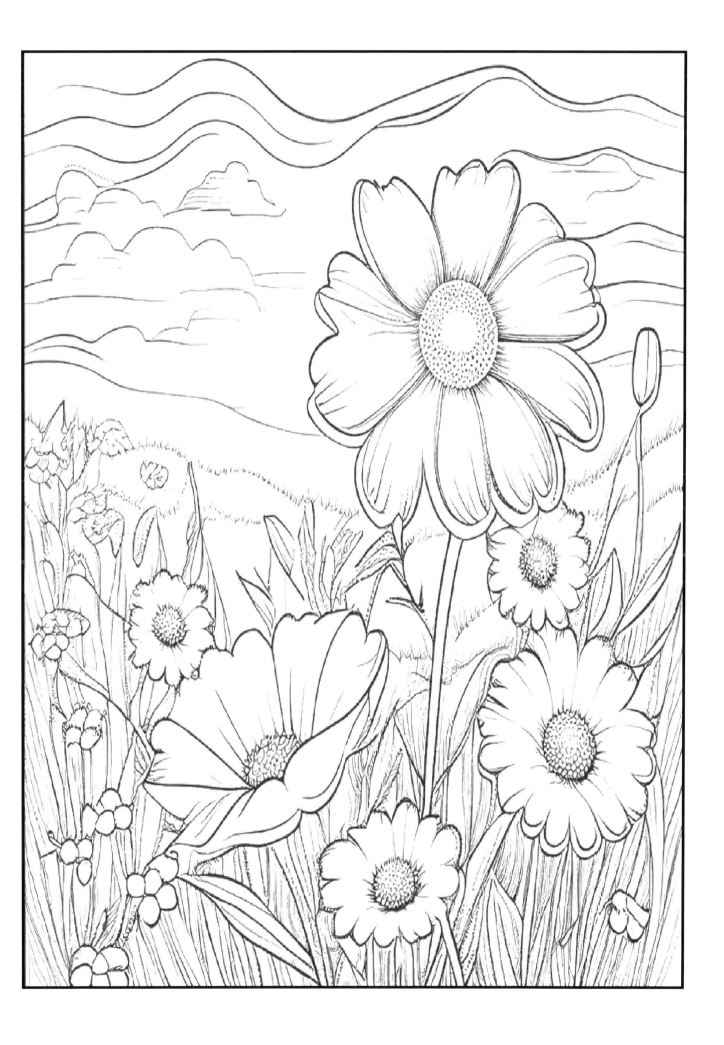

Serenity Landscapes: A Relaxing Coloring Book

Serenity Landscapes: A Relaxing Coloring Book

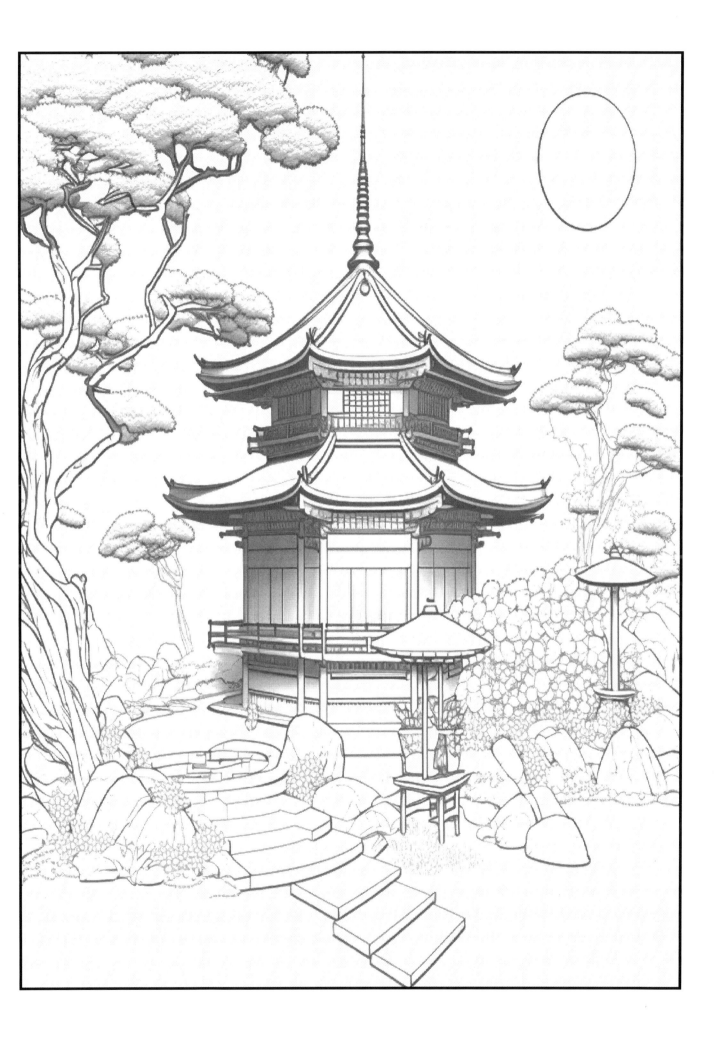

Serenity Landscapes: A Relaxing Coloring Book

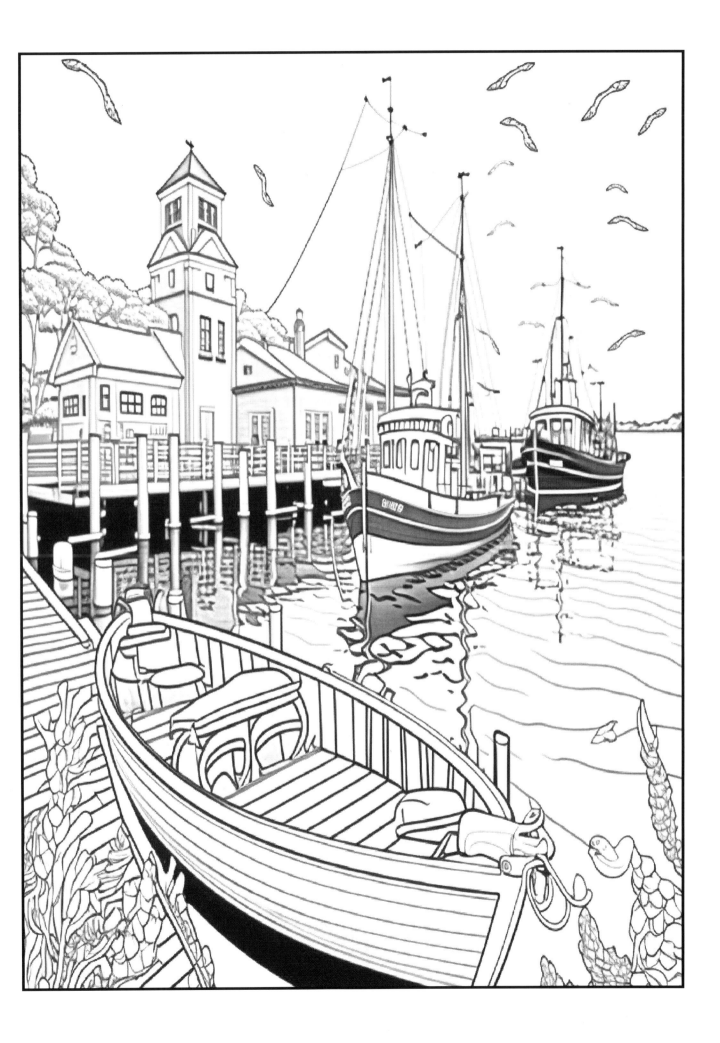

Serenity Landscapes: A Relaxing Coloring Book

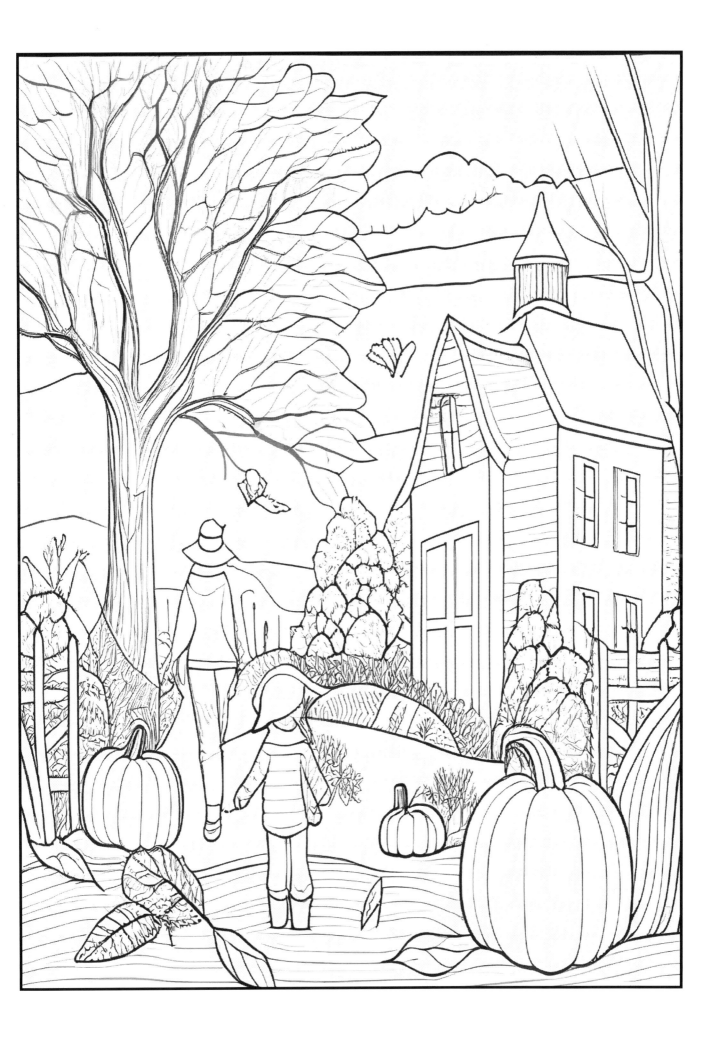

Serenity Landscapes: A Relaxing Coloring Book

Serenity Landscapes: A Relaxing Coloring Book

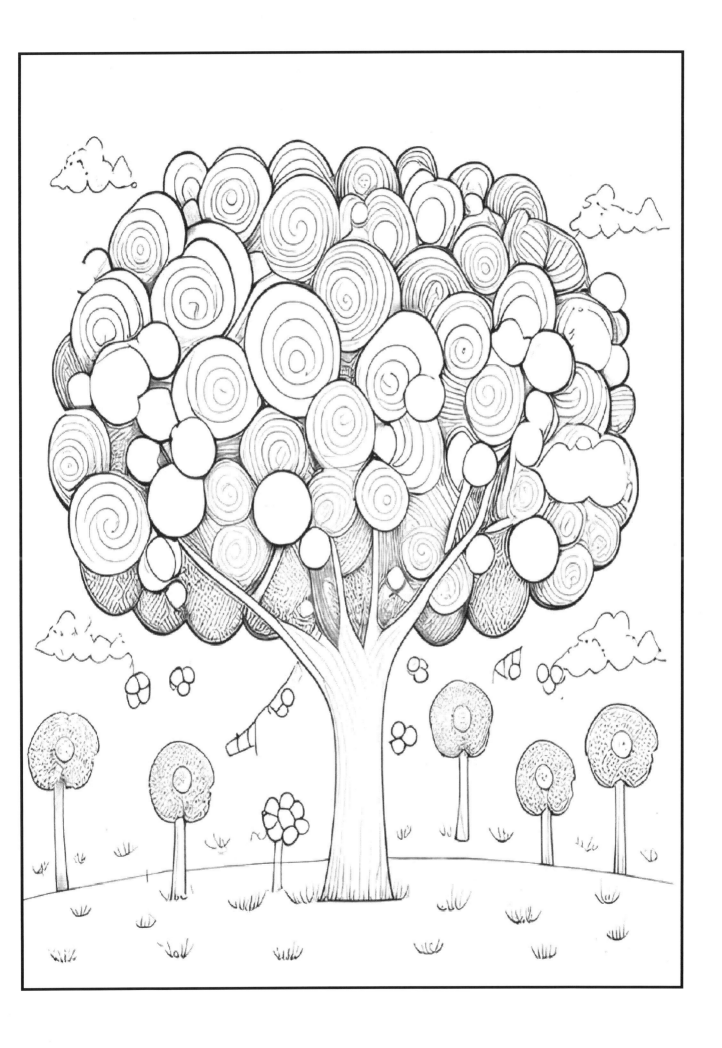

Serenity Landscapes: A Relaxing Coloring Book

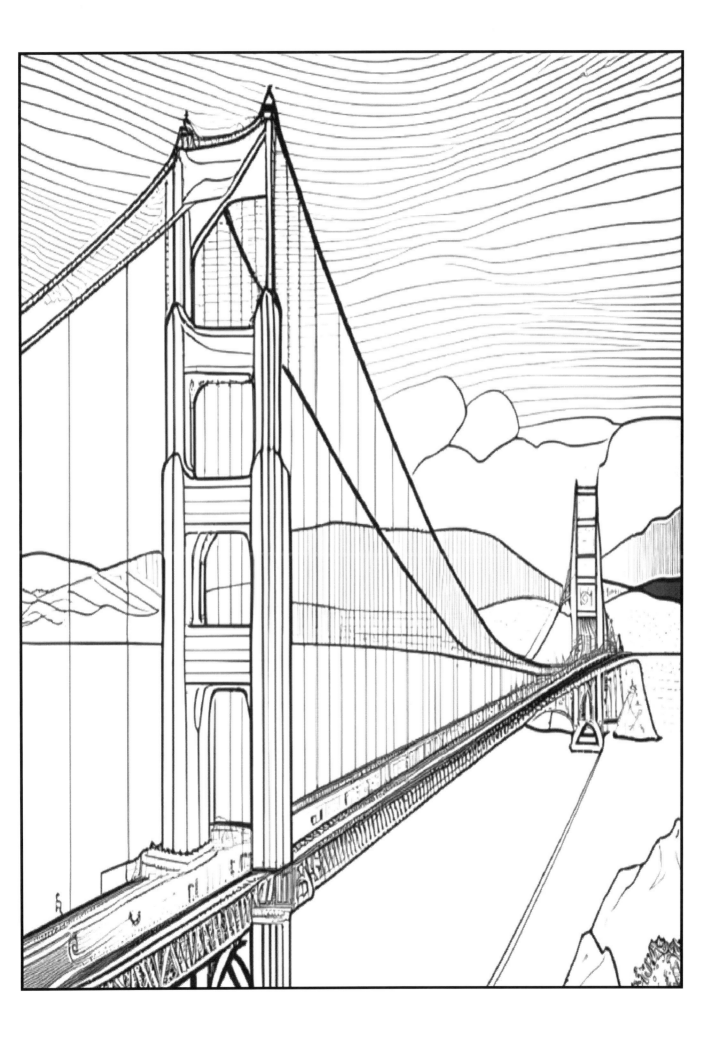

Serenity Landscapes: A Relaxing Coloring Book

Serenity Landscapes: A Relaxing Coloring Book

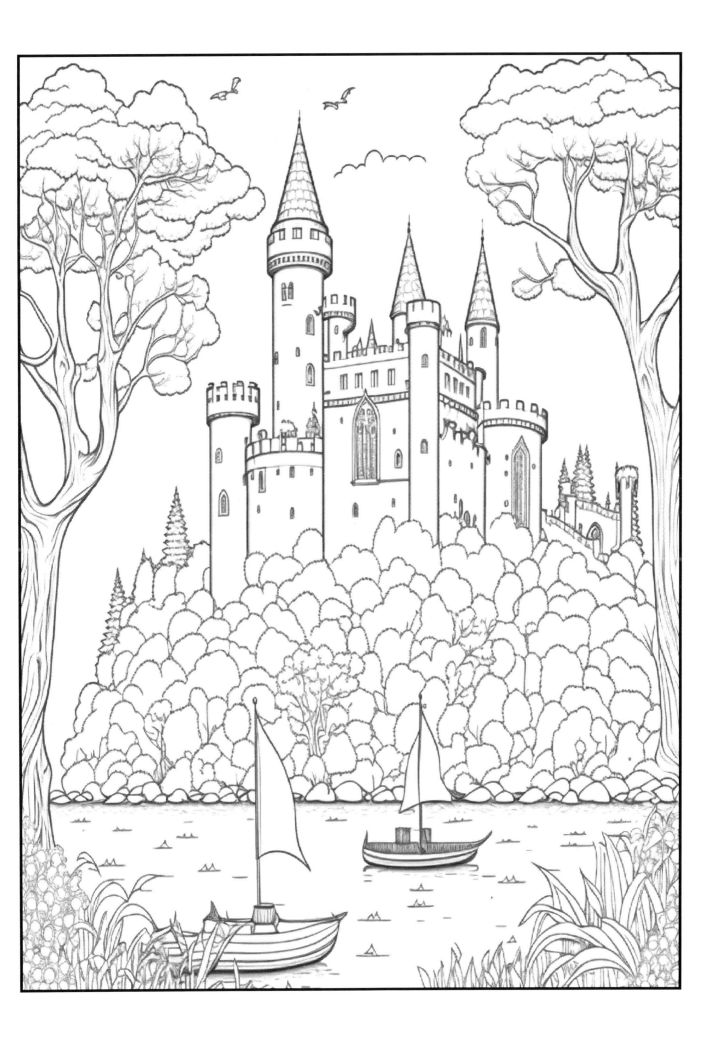

Serenity Landscapes: A Relaxing Coloring Book

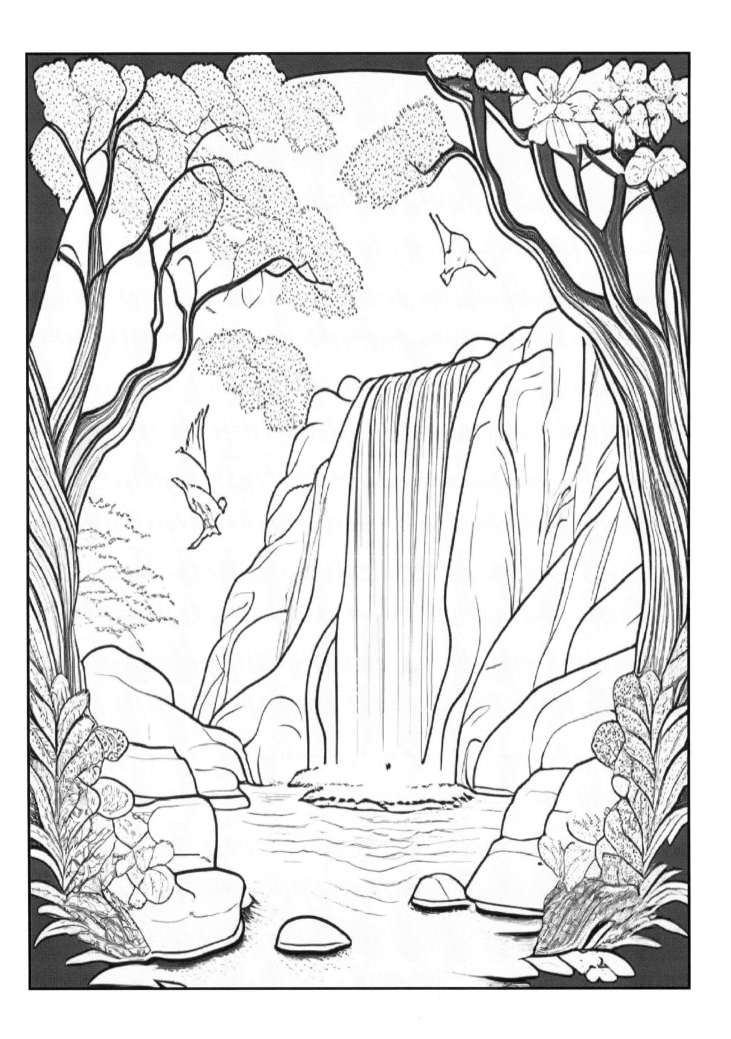

Serenity Landscapes: A Relaxing Coloring Book

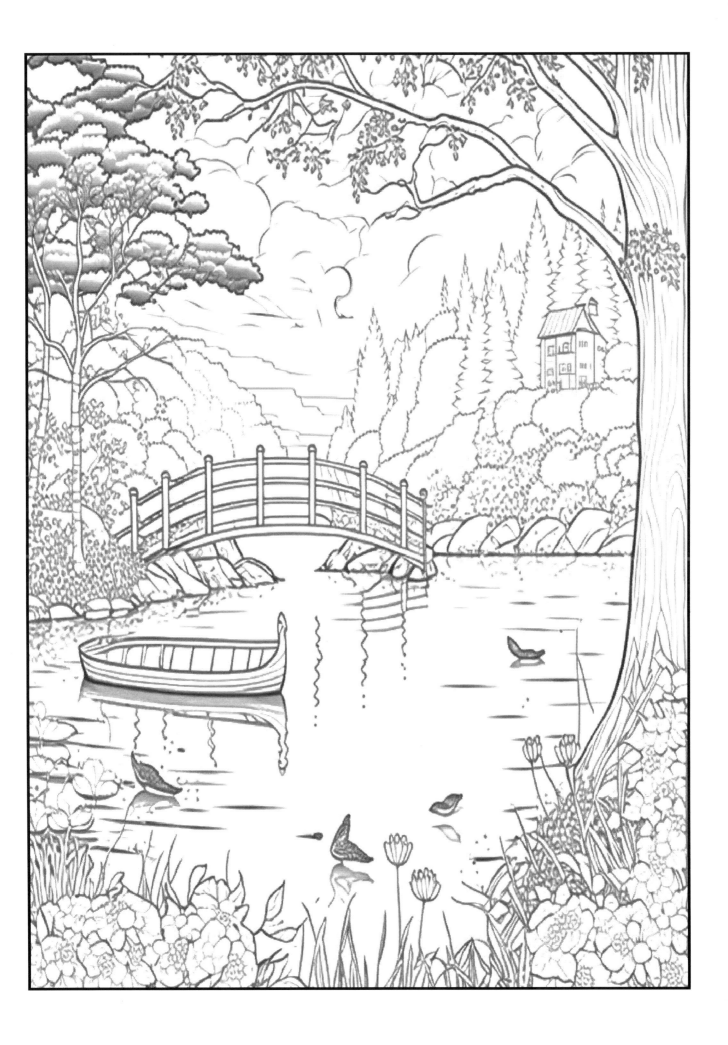

Serenity Landscapes: A Relaxing Coloring Book

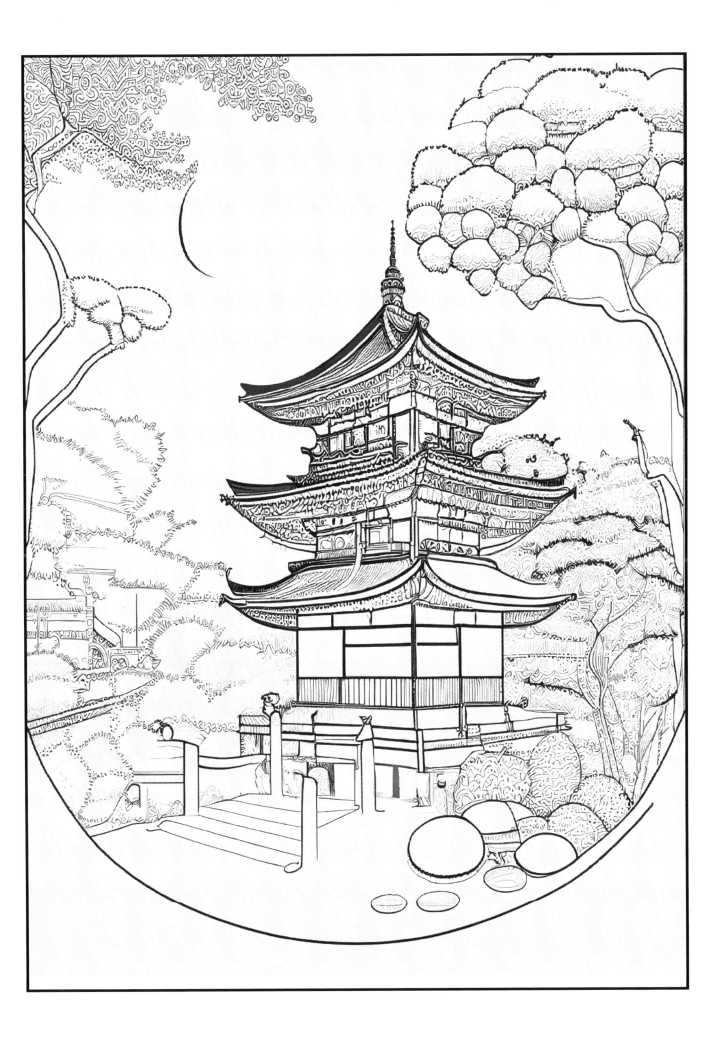

Serenity Landscapes: A Relaxing Coloring Book

Serenity Landscapes: A Relaxing Coloring Book

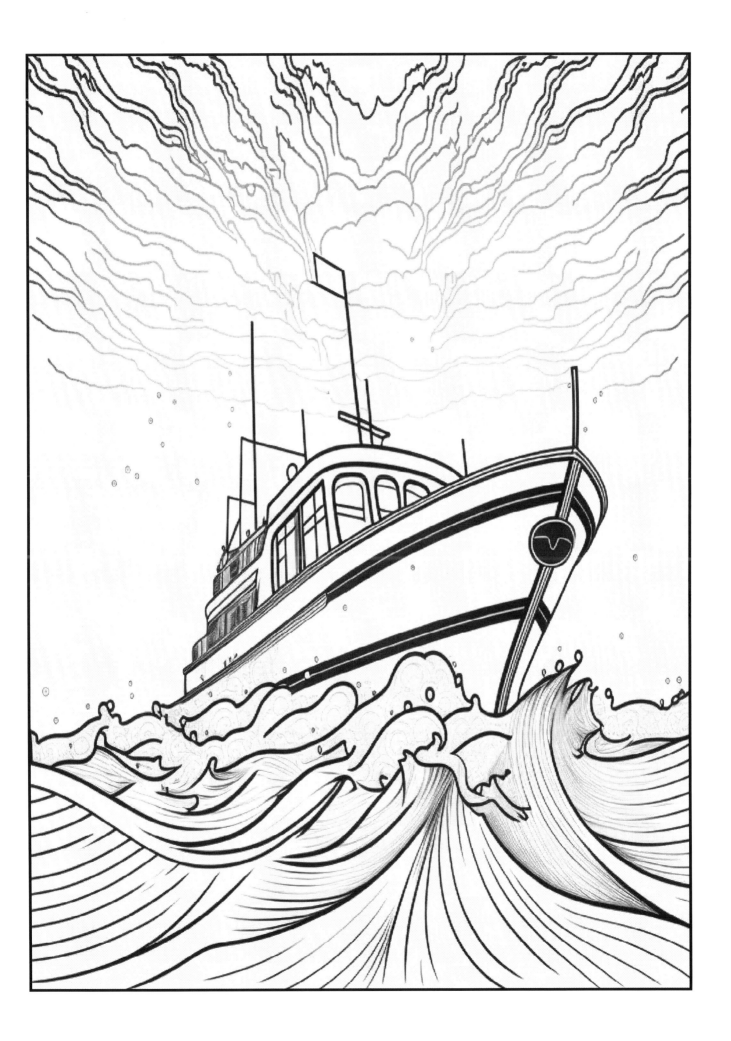

Serenity Landscapes: A Relaxing Coloring Book

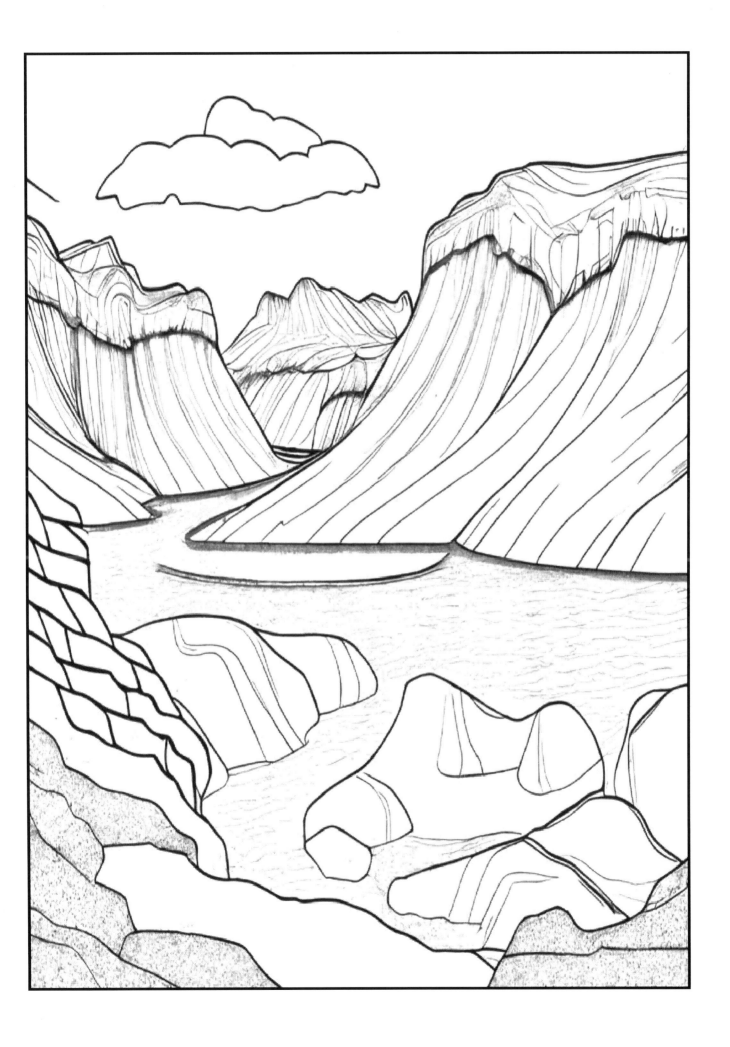

Serenity Landscapes: A Relaxing Coloring Book

Serenity Landscapes: A Relaxing Coloring Book

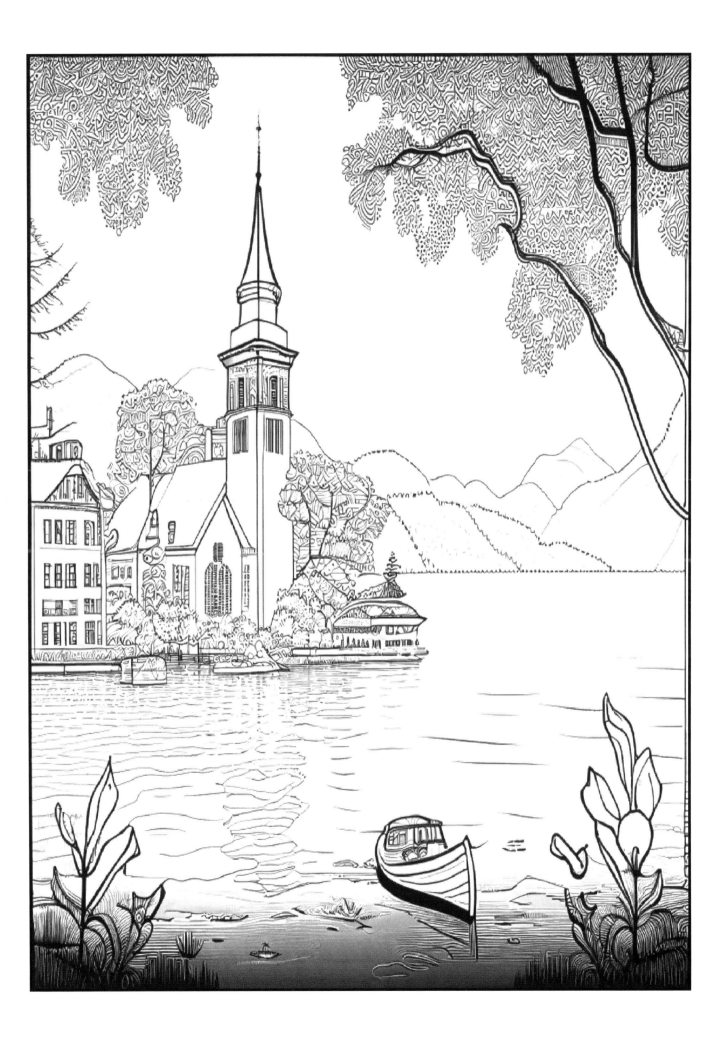

Serenity Landscapes: A Relaxing Coloring Book

Serenity Landscapes: A Relaxing Coloring Book

Serenity Landscapes: A Relaxing Coloring Book

Serenity Landscapes: A Relaxing Coloring Book

Serenity Landscapes: A Relaxing Coloring Book

Serenity Landscapes: A Relaxing Coloring Book

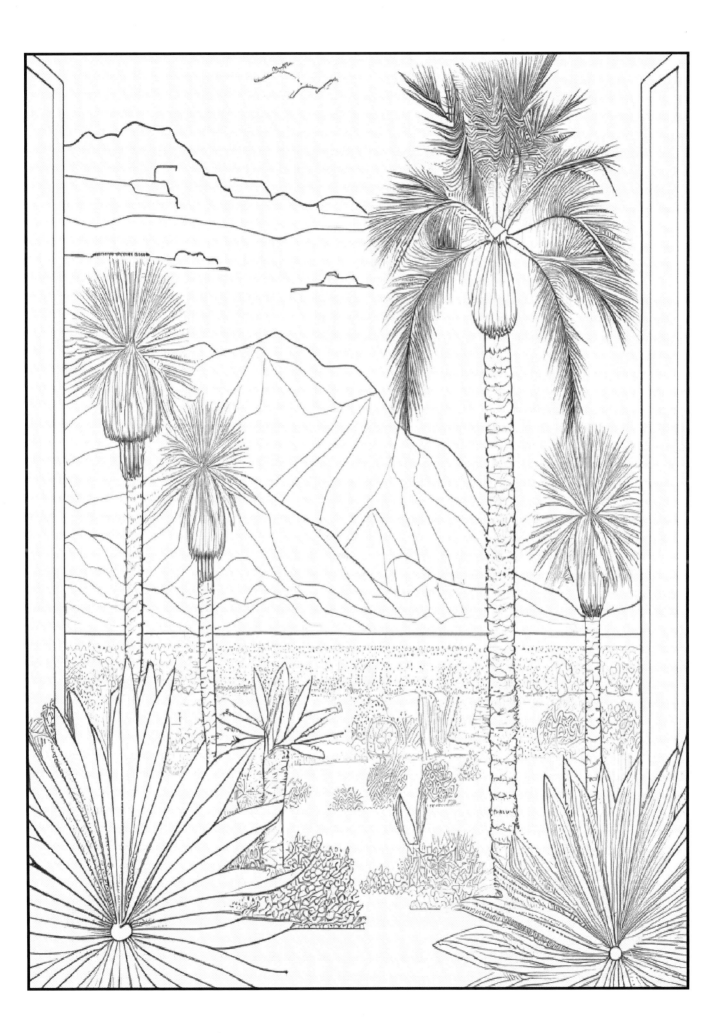

Serenity Landscapes: A Relaxing Coloring Book

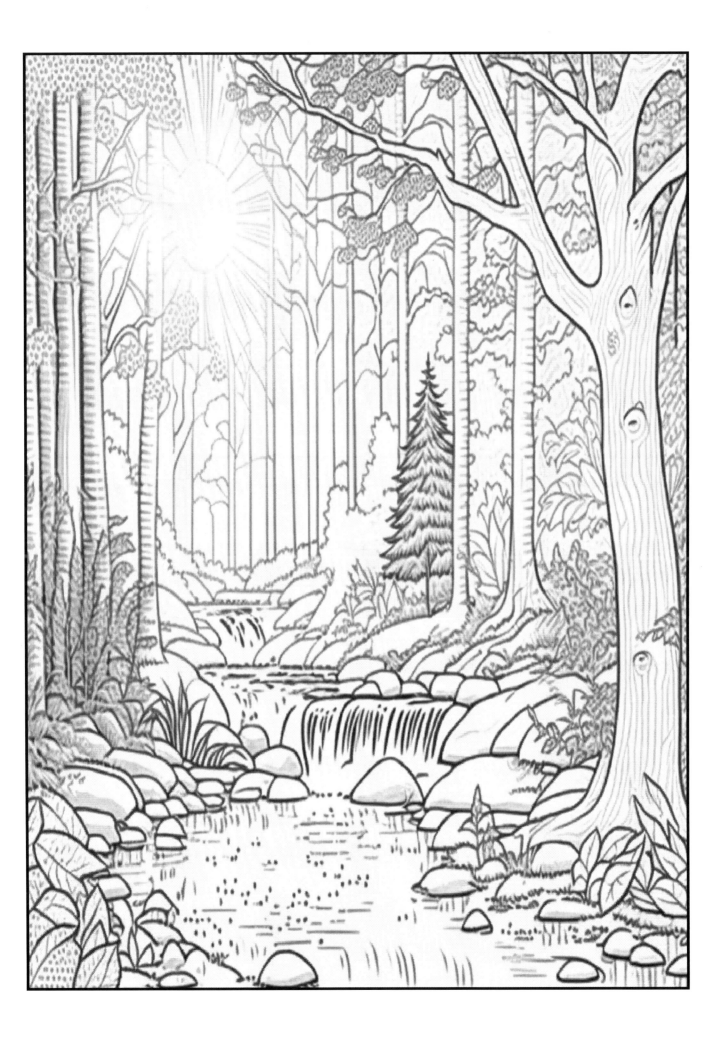

Serenity Landscapes: A Relaxing Coloring Book

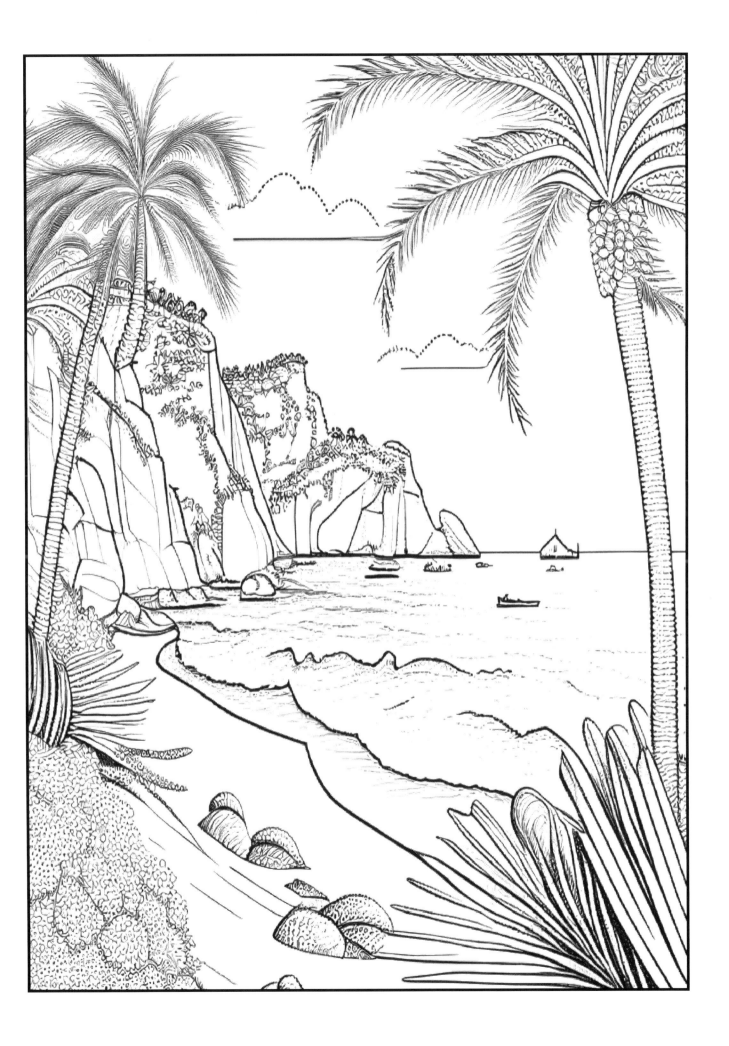

Serenity Landscapes: A Relaxing Coloring Book

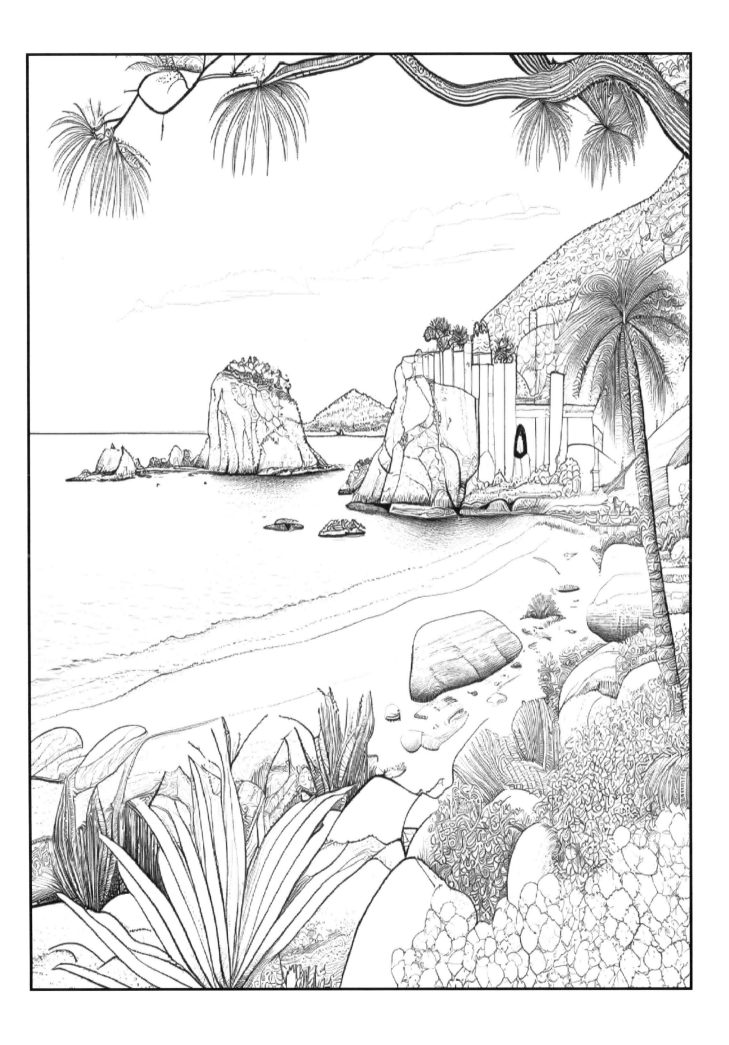

Serenity Landscapes: A Relaxing Coloring Book

Serenity Landscapes: A Relaxing Coloring Book

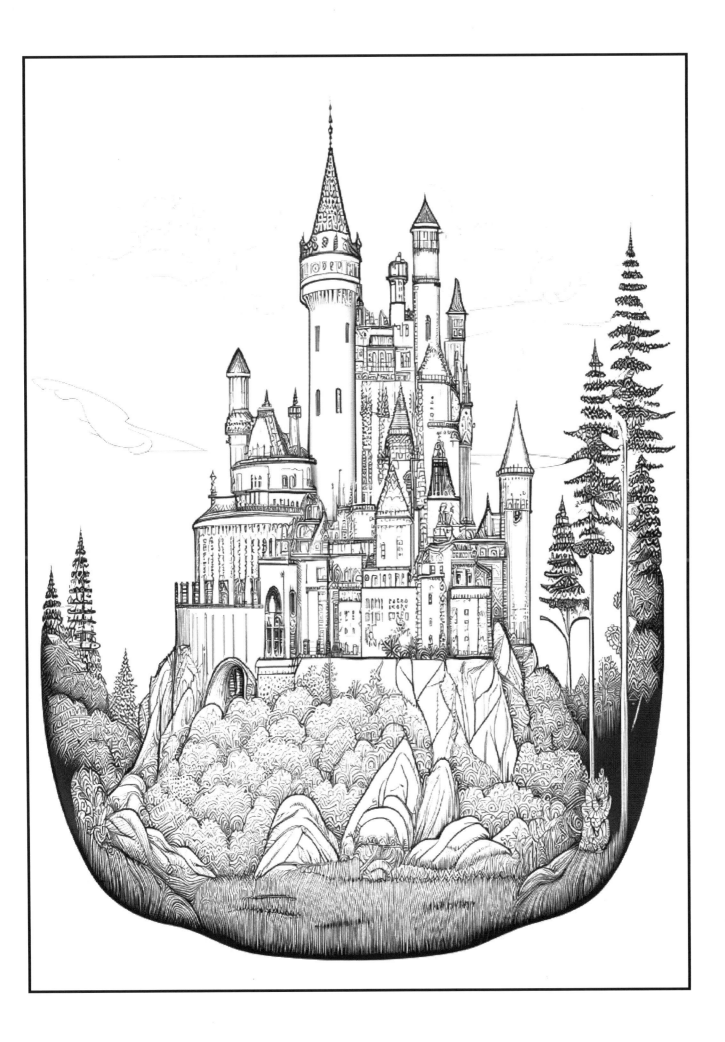

Serenity Landscapes: A Relaxing Coloring Book

Serenity Landscapes: A Relaxing Coloring Book

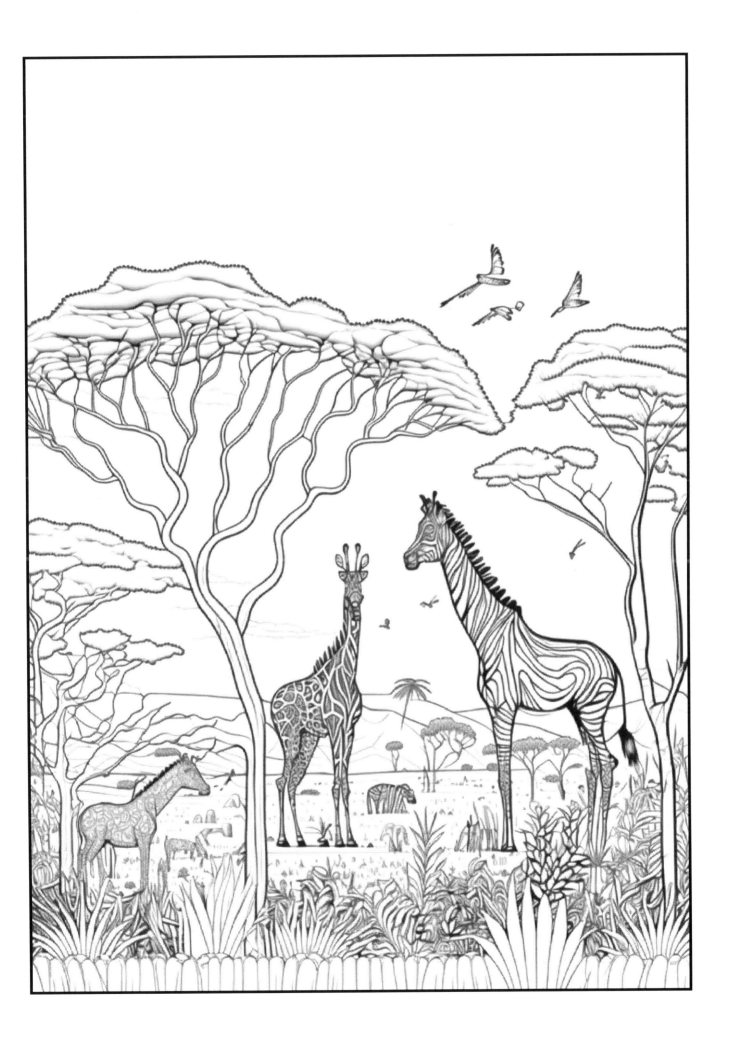

Serenity Landscapes: A Relaxing Coloring Book

Serenity Landscapes: A Relaxing Coloring Book

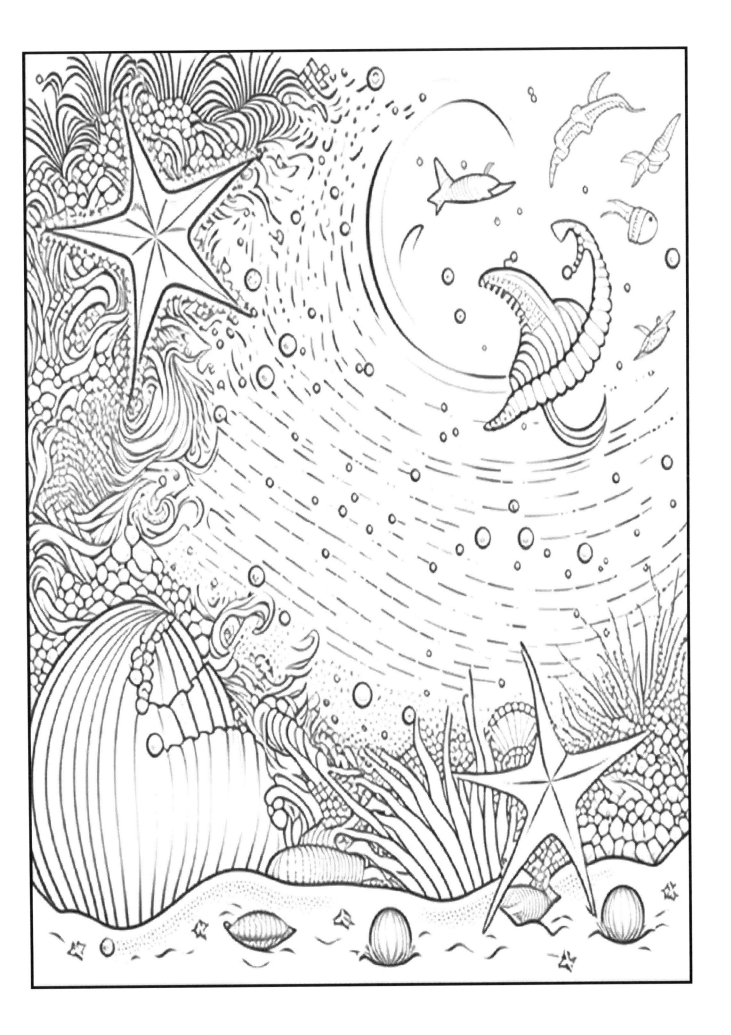

Serenity Landscapes: A Relaxing Coloring Book

Serenity Landscapes: A Relaxing Coloring Book

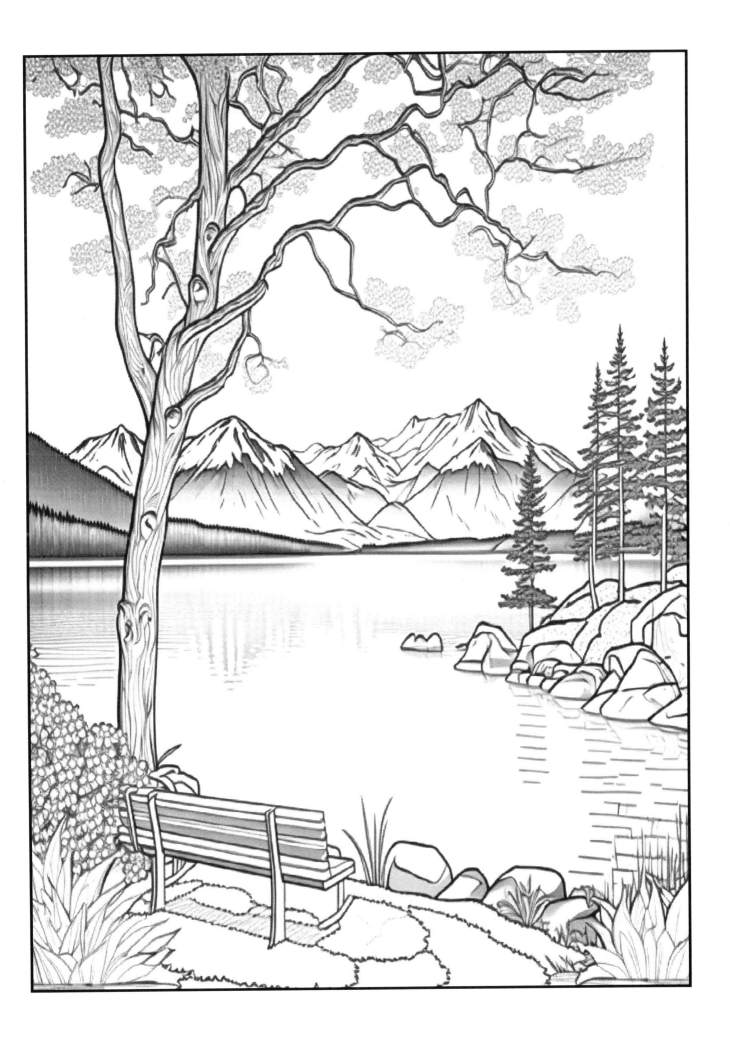

Serenity Landscapes: A Relaxing Coloring Book

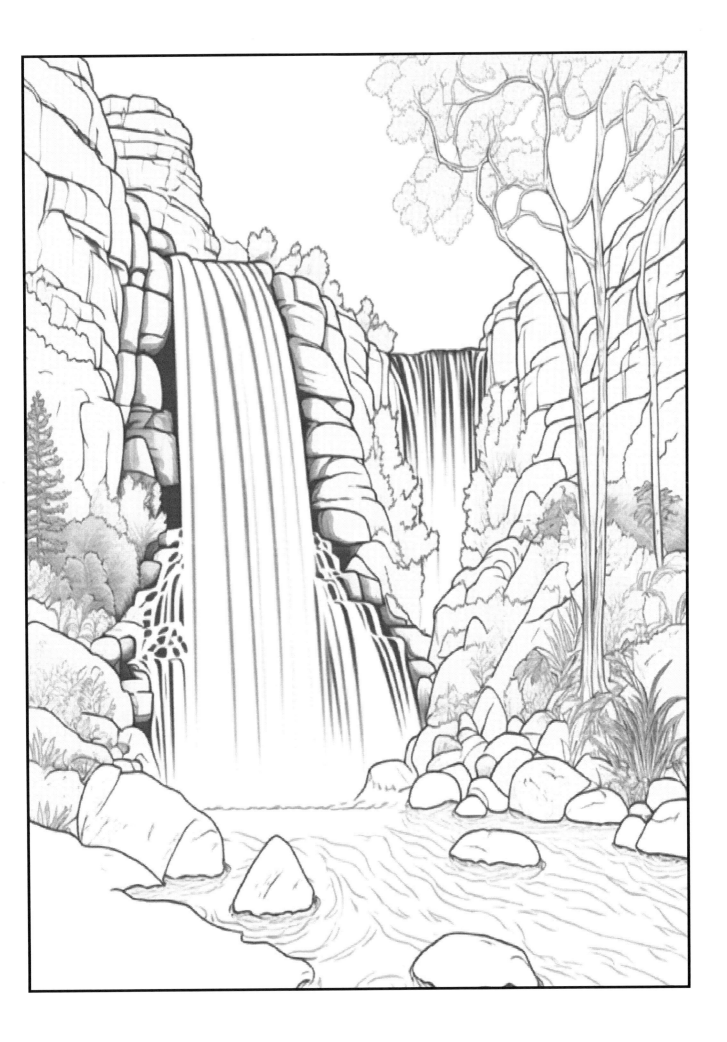

Serenity Landscapes: A Relaxing Coloring Book

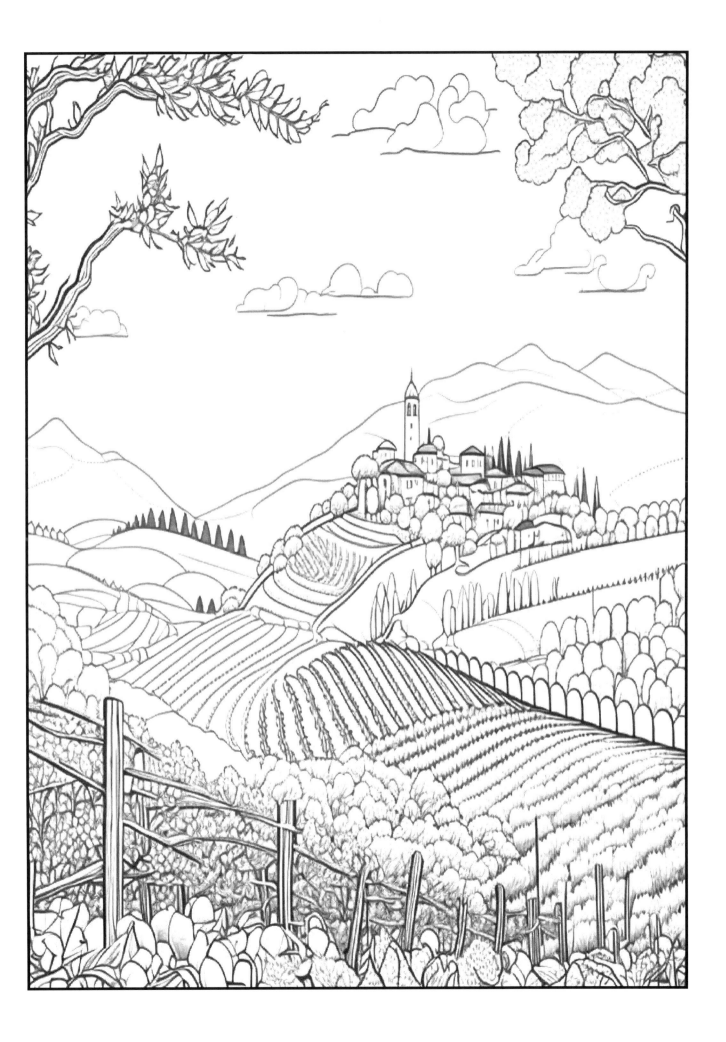

Serenity Landscapes: A Relaxing Coloring Book

Serenity Landscapes: A Relaxing Coloring Book

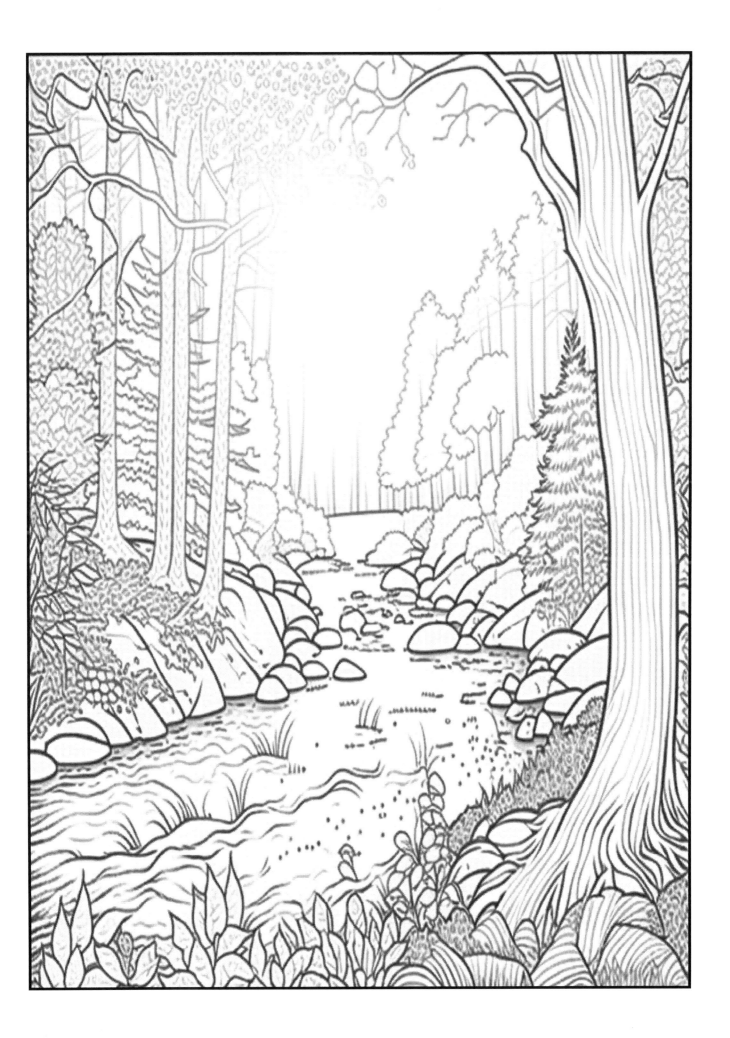

Serenity Landscapes: A Relaxing Coloring Book

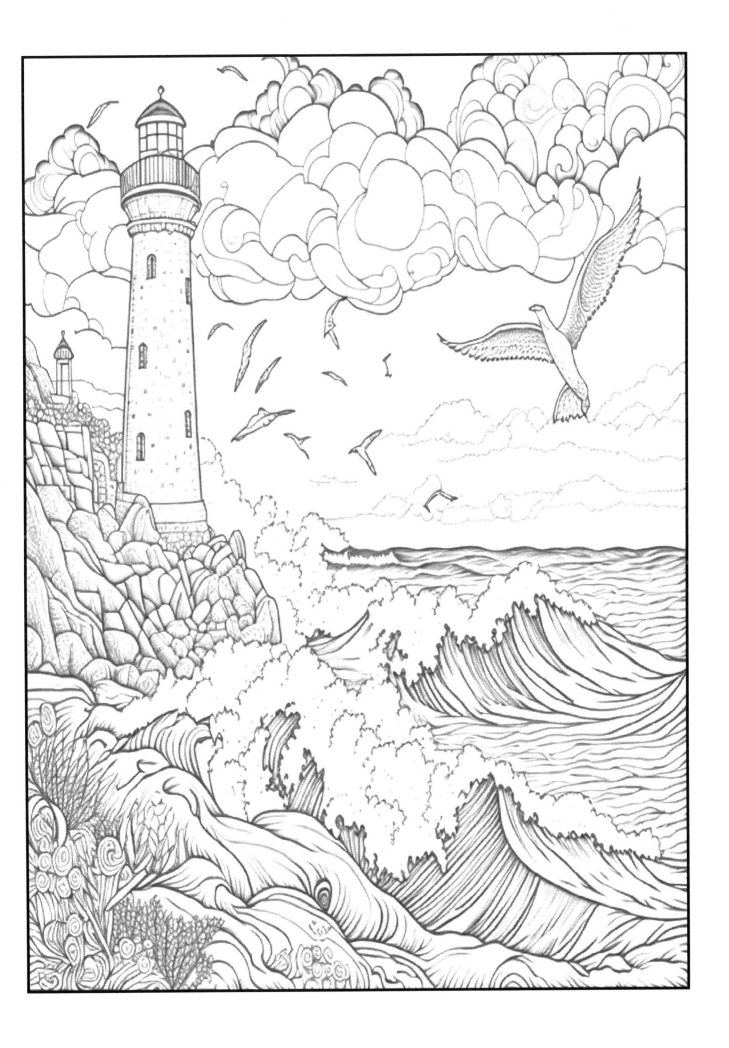

Serenity Landscapes: A Relaxing Coloring Book

THANK YOU SO MUCH

WE HOPE YOU HAD A DELIGHTFUL EXPERIENCE

If you loved our coloring book, we would be over the moon if you shared your experience with others on Amazon. Your review might just be the little nudge someone needs to find their new favorite coloring book. Plus, it would make our day!

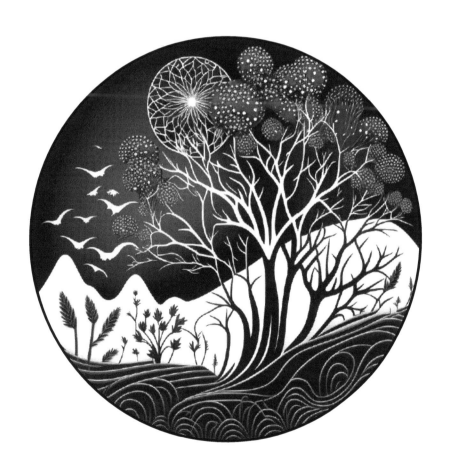

Made in the USA
Las Vegas, NV
27 July 2023

75305170R00055